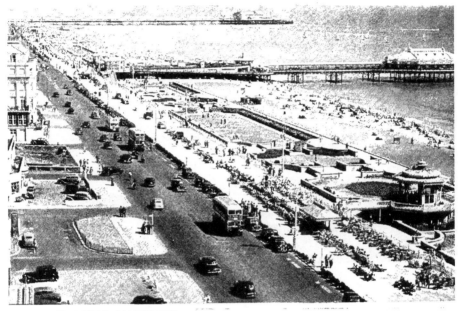

"DOCTOR BRIGHTON"

"Kind, cheerful, merry Doctor Brighton," so Thackeray spoke of it—this sparkling resort of the South Coast, which together with its sister-town of Hove forms one of the great pleasure cities of Europe. The original Dr. Brighton was a real person—Dr. Richard Russell, "The Father of Modern Brighton." It was his enthusiasm for sea-bathing, and even the drinking of sea-water as a successful treatment for many diseases, that established Brighton's fame over 200 years ago as a health and pleasure resort. Soon after, the Prince of Wales, son of George III, set the seal upon its fashionable reputation by establishing a house that eventually became the exotically beautiful Royal Pavilion. Almost every year until 1826, when age and illness prevented further visits, its Royal patron spent several weeks in the summer and at Christmas time in Brighton. Now it is visited each year by millions of people from all sections of society. The photograph above shows the magnificent sea front sweeping eastwards towards the distant chalk cliffs and downs; that on the right was taken from the West Pier. On the facing page the western beach and the sea-flanked terraces of Hove are seen.

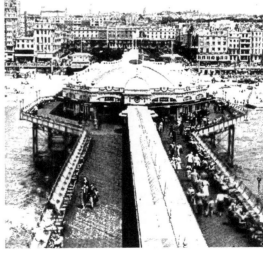

THE PICTORIAL HISTORY OF
BRIGHTON
AND THE ROYAL PAVILION

BY CLIFFORD MUSGRAVE, O.B.E.

Director of the Brighton Public Libraries and Museums

WHAT is the spirit that makes Brighton unique among holiday resorts? Perhaps it is partly the essence of all its natural endowments; its heady, salt-tanged air, the sunshine and the glittering sea. The atmosphere of Brighton has been compared to that of Naples or Seville, and certainly it possesses a brightness and a blitheness that fill one with a sense of liberation and the promise of delight.

Inevitably when we think of Brighton we think of the Regency, and it is true that the vitality, the robustness, the sense of freedom and pleasure which give this period its fascination are part of the genius of the town.

We owe to the Regency Brighton's beautiful architecture; the nobility and dignity of the grand squares and terraces of Kemp Town and Brunswick Town, the gleaming smartness of Royal Crescent, the gaiety and charm of innumerable little bow-fronted villas in the smaller squares.

But the Regency's especial gift to Brighton is the Prince Regent's own fantastic oriental palace, which in itself sums up the town's spirit of gaiety and elegance.

As a pleasure resort Brighton is largely modern: its early history is but that of a small fishing town. Even the name of Brighton did not come into general use until the late 18th century, although it was indeed mentioned in this way in the time of Henry IV. In early days the town was mostly called Brighthelmstone, and in different ages there have been such variants as Brighthelmston, Brithampton, Bristelmestune and even Brighamsted.

The name has been romantically supposed to derive from the shining crest of an imaginary Saxon chieftain, Bright Helm, but it is more prosaically believed to come from the Saxon *Beorthelm's*

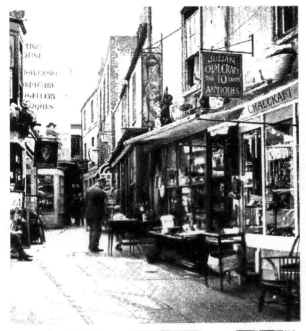

THE LANES

The picturesque Lanes lie in the heart of Brighton between the three streets that were the town boundaries in ancient times, North Street, West Street and East Street. The houses have been rebuilt many times, and mostly do not date from earlier than the eighteenth century, but they preserve in their narrow ways the original plan of medieval Brighton. Here the houses are so close together that neighbours can speak to each other and touch from their upper windows, but in parts The Lanes open out into little courts with sheltered gardens, one of which contains a large fig tree. In the maze of alleys are gathered many antique and curiosity shops, where treasures are still to be found, and one can wander for a long time far from the bustle of traffic.

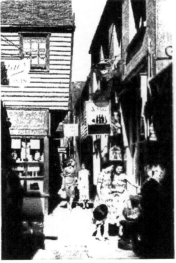

EARLY HISTORY

Tun or *Brithelm's Tun*, the farm of *Beorthelm* or *Brithelm*. However, the bright helm remains as the crest of the Borough arms.

Prehistoric men built hill forts at Whitehawk and Hollingbury. Gold bracelets and a rare amber cup of the Bronze Age are in the Brighton Museum. Romans and Saxons had their settlements here.

The earliest records are of the time of Ethelred the Unready. King Harold raised levies from Brighthelmston to repel the Normans, but with the Conquest William granted the town to William de Warenne, husband of Gundrada, who is believed to have been the Conqueror's daughter. The Domesday Book tells us that *Bristelmestune* paid a rent of 4,000 herrings a year, and it was valued at twelve pounds.

In the Middle Ages most of the town lay below the cliffs, but the encroachment of the sea forced people to build above, and an Upper and Lower Town came to exist. The fishermen mostly lived below, the landsmen above, and there were bitter feuds between them.

In 1545 Admiral Prégent de Bidoux, known to the English as "Prior John," with over 200 ships landed a force of men and burned the whole of the town except for the walls of the 14th-century church of St. Nicholas. After the French attack a blockhouse with a battery of guns was built in 1558 near the bottom of West Street. It was erected "in warlike manner by the fishermen with the profites of the quarter-share" from fishing, but in 1579 the fishermen petitioned for some relief from the cost of defence. Accordingly they were ordered by a Commission to "sette down in writynge their auncient customs and orders." The Commission also set up a new body for the government of the town. This was known as "The Society of Twelve" as it consisted of the "auncientest, gravest, wisest inhabitants, eight Fishermen and fower landemen for assistants to the Conestable." At this time the town possessed 80 fishing boats, 400 able mariners and 10,000 nets.

Brighton's later fame was to come through the patronage of a monarch, but even in its 17th-century obscurity the town was to play a part in the life of a king, and be lit for a moment by the torch of history. This was the occasion when Charles II stayed the night at an inn in Brighton, before escaping to France after his *Continued on page 4*

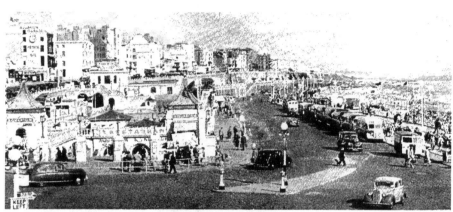

THE AQUARIUM

Yielding only in fame to the Royal Pavilion itself the Aquarium (*above*) has been one of Brighton's most celebrated places of amusement, where the wonders of the sea could be studied in comfort indoors. It was opened in 1872 by the Duke of Edinburgh of that time in response to the growing spirit of scientific enquiry. But the pale green twilight of the underground halls was found more popular by lovers and honeymoon couples, who discovered there a congenial darkness and seclusion. Above it, the sea-front stretches eastwards to Black Rock and the distant cliffs, while on the seaward side the Madeira Drive overlooks the wide eastern beaches of Brighton with Volk's toy-like electric railway running between the beach and the roadway.

BLACK ROCK

Here an immense block of modern flats marks the beginning of the coast road and the cliff-top walk to Rottingdean and Saltdean. At Black Rock there is the town's finest swimming pool (*left*), with a children's pool and a restaurant.

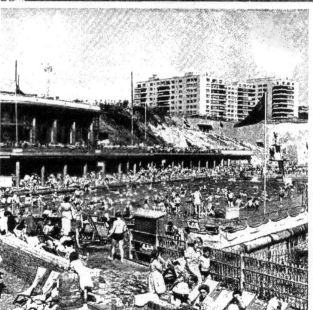

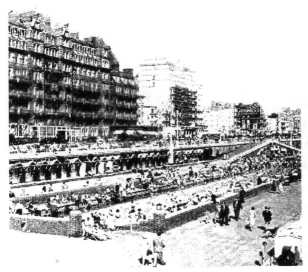

WORLD-FAMOUS HOTELS

The great hotels of Brighton are legendary in the history of the town. The Grand (*centre of photograph, above*) was built in the Italian manner of white stucco, with balconies, in 1864. The Metropole (*left*) was built of red stone and tiles in 1890. In Victorian and Edwardian days these were the haunts of South African gold and diamond millionaires, of wealthy speculators and race-horse owners, the idols of the stage, and the Royalty and nobility of many lands. The Royal Albion Hotel (*below*) stands on the site of Dr. Russell's house. Here that remarkable personality, the diminutive but great-hearted Sir Harry Preston, friend of princes and peers, received up to his death in 1936 the celebrities of fashion, sport and the stage. Westwards along the front is the Old Ship Hotel (not shown), Brighton's oldest hostelry, dating back to at least 1559.

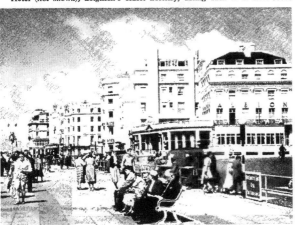

"OCEANIC FLUID"

defeat at Worcester in 1651. The inn was probably one at the bottom of West Street.

After his Restoration, the King re-named the vessel that had carried him to safety the *Royal Escape*, and awarded its owner, Captain Tettersell, a generous pension. Later Tettersell became Constable of Brighton, and was much hated for his persecution of Quakers and other dissenters.

Until early in the 18th century the fortunes of Brighton were at a low ebb. Great storms swept away the remains of the fort and the houses beneath the cliffs, and, as one historian wrote, the town looked as if it had been sacked by an enemy. The fishermen were too poor to pay for the wooden groynes that were needed to protect the shore, and money had to be raised from collections in churches all over England.

When Daniel Defoe visited the town in 1720, the prospects of Brighton were beginning to improve, and it was already in favour as a port of embarkation for France. Before long the movement began that was eventually to make the town almost a symbol of the highest prosperity and sophistication. This was the gradual awakening throughout England of a pleasurable interest in the sea. "To the thoughtful mind" one visitor wrote later "the sea is always an interesting object," and to the delight of watching its changing colours and varying moods was joined the notion, put forward by several doctors then, that it was health giving, not only by bathing in it, but by drinking "the oceanic fluid."

It was a Dr. Richard Russell of Lewes who set the stamp of fashionable approval upon the new treatment by sea-water. In 1750 he published an important treatise in Latin, a translation of which under the title *A Dissertation Concerning the use of Sea Water in Diseases of the Glands* appeared three years later. This book was one of the principal factors in that momentous occurrence, the "Invention of the Seaside."

Dr. Russell's patients soon became so numerous that he built himself a house at Brighthelmston on the sea-front, where the Royal Albion Hotel now stands.

Sea bathing for health was regarded as a solemn and rigorous ritual, and there were muscular attendants—"bathers" for men and "dippers" for women—who saw to it that the immersions of their customers were thorough.

Continued on page 6

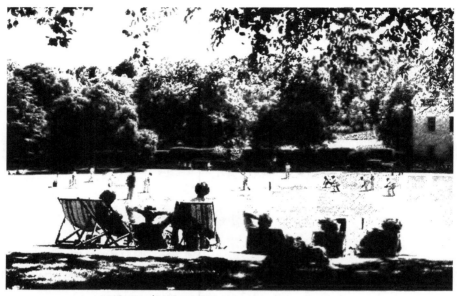

BRIGHTON'S BEAUTIFUL PARKS AND GARDENS

The gardens of Brighton fitly match in their beauty the splendour of its buildings. The great park of Stanmer (*above*), with its 18th-century house that was once the seat of the Earls of Chichester, is a lovely valley of man-made landscape, focussing upon a picturesque church and village pond. The new University of Sussex will soon be built nearby. At the west end of the sea front are quiet lawns and sunken gardens (*below, left*). In this picture the Peace Memorial which marks the boundary of Brighton and Hove is seen. It was erected in 1912 to the memory of King Edward VII. In Preston Park is a Garden for the Blind (*below, right*), providing delights of scented flowers and nearby is Preston Manor, another 18th-century house, containing treasures of furniture, pictures and silver.

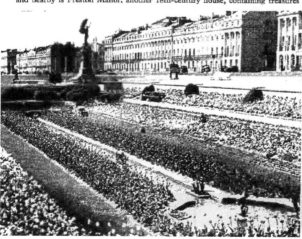

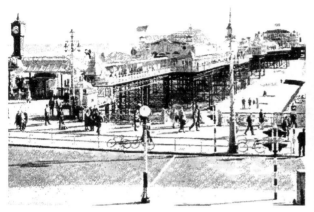

PALACE PIER THE SEA WALL

The Palace Pier (*above*) with its oriental arches and gilded domes inspired by the Royal Pavilion, and its filigree ironwork, is one of the most delightful piers in existence. Among the pleasures it offers are an excellent theatre, the contemplative delights of fishing, and the naïvely amusing penny-in-the-slot machines that reveal the mysteries of "The Haunted House" and "What the Butler Saw." But if you wish for a more solitary promenade than the pier there is the four-mile long Undercliff Walk (*below*), between Black Rock and Saltdean, where a massive sea-wall protects the chalk cliffs from the incessant attacks of the sea.

MARTHA GUNN

The tribe of "bathers" and "dippers" achieved fame through their two redoubtable leaders. "Smoaker" Miles once prevented the Prince of Wales from risking his life in a rough sea by threatening him with his fists, and on another occasion he is said to have pulled the Prince back to safety by his ear. Martha Gunn's family had been established in Brighton for over 200 years, and her descendants flourish there to this day. She carried on her profession from the beginning of organised bathing in 1750 until her death in 1819. With other famous Brighton characters she is buried in St. Nicholas's churchyard.

The success of sea-bathing to some extent rivalled the popularity of taking the waters at fashionable inland spas such as Bath and Leamington, but Dr. Russell was fortunate enough to combine the attractions of both at Brighton when he discovered at Wick in Hove a spring of chalybeate waters similar to those of Tunbridge Wells. Here, in what is now St. Anne's Well Gardens, he formed a pleasant little spa.

Dr. Russell's two successors, Dr. Relhan and Dr. Awsiter, were advocates for the drinking of sea-water: the latter even recommending it to be drunk with milk, or with cream of tartar, to make it more effective.

The cure was no doubt highly beneficial though somewhat rigorous, if only by providing a little salutary hygiene, both inside and out, and achieved some astonishing successes in those days of insufficient washing, and excessive indulgence in food and drink.

But sea-bathing in the 18th century was not devoid of pleasure. Fanny Burney, the charming author of the novel *Evelina*, tells in her diary how she and Mrs. Thrale with her two daughters made an excursion before dawn to the beach one cold November morning in 1782, and "bathed by the pale blink of the moon," returning home to dress by candlelight before returning by coach to London.

The friends of that famous hostess of literary and theatrical personalities, Mrs. Thrale, were among the first visitors of distinction to Brighthelmston, and with them came from time to time to stay at her house in West Street not only Fanny Burney, but Dr. Johnson. It was during his first visit in 1765 that the "Great Cham" of literature first looked on the sea.

Page 6 *Continued on page 8*

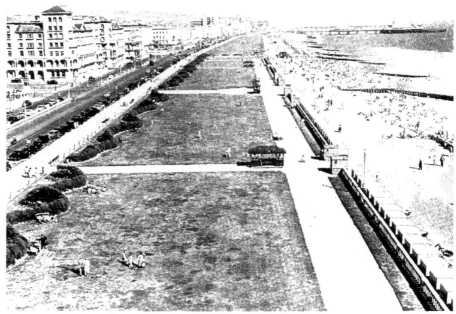

SEVEN MILES OF SUNNY PROMENADES

The magnificent sea-front of Brighton and Hove, the most splendid in the world, owes its elegance and dignity to the gleaming façades of the great Regency classical terraces that were inspired by the palatial terraces built by John Nash in Regent's Park. The Brunswick Lawns at Hove (*below*) give an atmosphere of spaciousness and repose to the sea-front, and were the scene of famous fashionable parades after church on Sunday mornings in Victorian and Edwardian times. Washed by sea and sun, the sea-front is the highway to downs and cliffs stretching Eastwards.

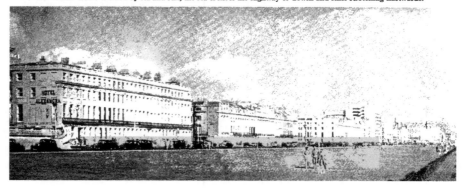

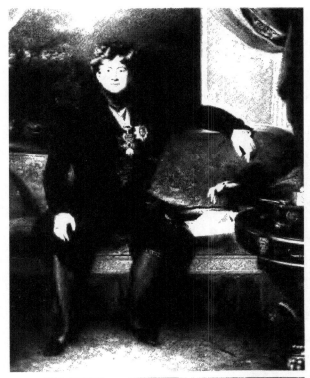

THE PRINCE REGENT

George IV, as Prince of Wales, Prince Regent, and King, assured Brighton's fame by his Royal patronage. His secret marriage to the beautiful Mrs. Fitzherbert in 1785 invests the town's history with the sparkle of romance. Although criticised for his weaknesses of character, the good that he achieved lives after him, in the shape of the splendid buildings of Georgian London, the Royal collection of pictures, furniture and plate, and not least, the Royal Pavilion. This portrait is by Sir Thomas Lawrence; that of Mrs. Fitzherbert is by Richard Cosway.

ROYAL VISITOR

There were then two principal hotels, the Castle Tavern and the Old Ship. The Castle Tavern, which stood on the site now occupied by the Electricity building, was opened in 1755, to cater for the new visitors, but both places were soon compelled to enlarge their accommodation. A follower of Robert Adam, John Crunden, the architect of Boodle's Club in St. James's, built a graceful ballroom in the style of his master at the Castle in 1766, and at the Ship a ballroom and cardroom, designed by Robert Golden, were opened a year later. These handsome Assembly Rooms happily survive today. The proprietor of the Old Ship commemorated the person who had made Brighton a popular resort by hanging in the ballroom a fine portrait of Dr. Russell by Benjamin Wilson, a fellow member with Dr. Russell of the Royal Society.

In the day-time social life revolved around the bookshops and circulating libraries. One was made free of their privileges by entering one's name in a visitors' book, and paying a guinea. The Master of Ceremonies issued invitations to the evening assemblies, and effected suitable introductions. His office soon became as important at Brighthelmston as it had been in the days of Beau Nash at Bath. In fact, the first M.C. was a Captain Wade, who was one of Nash's successors, and divided the summer and winter seasons between the two towns. The M.C. not only arranged the dances held on alternate nights at the Assembly Rooms and all the other social events, but was the final arbiter on all questions of social conduct in the public places. On Sunday evenings in the season a Promenade and Public Tea took place at the Assembly Rooms.

One Sunday in September, 1783, a visitor of unusual distinction appeared at the Promenade at the Castle. This handsome, though slightly plump young man, was George, Prince of Wales, son of George III. His arrival during the afternoon had been marked by a ringing of the church bells and a discharge of cannon on the front.

Having just reached the age of twenty-one the Prince celebrated his independence by escaping from the severe Teutonic domination of his father and stayed for three days, walking on the Steine, visiting the theatre, and attending a ball. In the

Continued on page 14

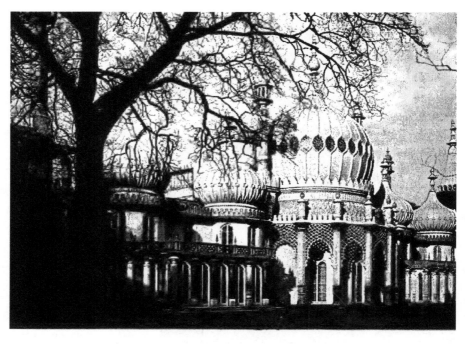

THE ROYAL PAVILION

The Royal Pavilion appears upon its tree-encircled lawns by the sea like a fabulous Indian palace brought by Oriental magic. John Nash, the Prince Regent's architect, completely transformed the existing classical villa by adding two great new State Apartments, a Banqueting Room and a Music Room, at the ends, but with the Indian domes, minarets, pinnacles and pagoda roofs he gave the building a touch of poetic beauty that made it appear as though created in a single flash of inspiration. The Indian style in which the Pavilion is built is an expression of the intense romantic interest which had been aroused by poets and artists at the time in the wonderland of India. Although much criticised in the past for its fantastic character, the Pavilion is a building of extreme loveliness. Nowhere does the profusion of ornament overwhelm its harmonious proportions, and the curves of its domes and arches are of exquisite grace and subtlety. The form of the original building may be discerned in the central rotunda and flanking wings, but the design of the whole has been given unity by the long battlemented cornice, and by the beautiful pierced stonework lattices before the windows which cause dappled patterns of sunlight and shadow to fall upon the stucco walls behind. Nash's transformation, begun in 1815, was completed in 1822.

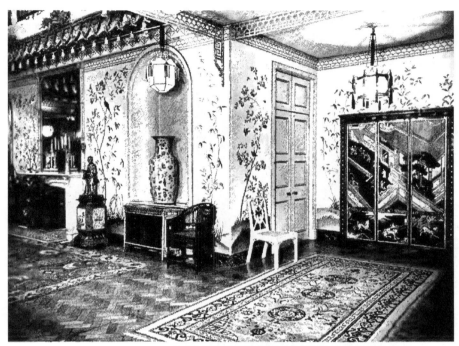

THE GRAND CORRIDOR

In the Grand Corridor (*above*) is to
be seen much of the original furni-
ture of the Royal Pavilion which
has been returned to the building
from Buckingham Palace in recent
years by the gracious wish of H.M.
The Queen, including the painted
lacquer cupboard, the bamboo
chairs, and the cabinets of bamboo
and lacquer. Here, too, the wall
decoration of the Grand Corridor
has recently been restored to its
former beautiful Chinese colour
scheme of delicate pink and blue,
in place of the sombre decoration
introduced in Victorian times.

THE SALOON

The Saloon (*right*), with its Chinese
hand-painted wallpapers of birds,
butterflies, flowers and shrubs on a
yellow ground, is one of the most
elegant rooms in the Pavilion.
The circular Chinese carpet repeats
the shape of the domed ceiling.

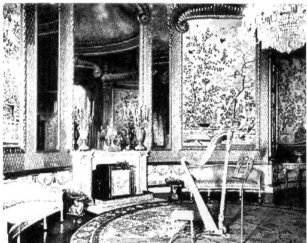

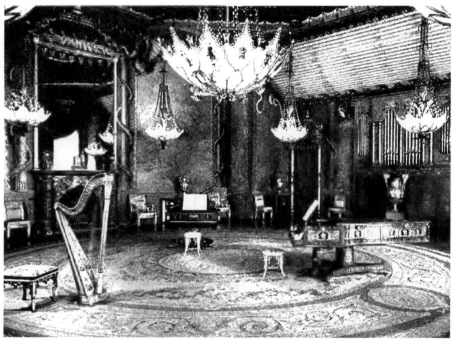

THE MUSIC ROOM—ONE OF EUROPE'S GRANDEST INTERIORS

The Music Room (*above*) with its waterlily chandeliers, and immense wall-paintings of Chinese landscapes in
scarlet, gold and yellow lacquer, is one of the grandest interiors in Europe. The pianos, with brass inlay designs
in rosewood, are of the same make as those used in the Pavilion in the Prince Regent's time and bear the date 1817.

THE GREAT KITCHEN AND MRS. FITZHERBERT'S ROOM

The Great Kitchen (*below, left*) has much of its original equipment and fittings, including the revolving spits at the
fireplace, the bronze smoke canopies and the lanterns. "Mrs. Fitzherbert's Drawing Room" (*below, right*) has some
of the furniture from her own Brighton house, and is decorated in the style of her first years with the Prince of Wales.

THE BANQUETING ROOM

The Banqueting Room of the Royal Pavilion is here shown arranged for the Regency Exhibition which is held every summer during July, August and September, when the scene represents a banquet of King George IV. The silver-gilt candelabra and dessert stands and sideboard dishes belong to the Ambassadorial silver of the Londonderry family, which is on long-term loan to the Pavilion. It was mostly made by Paul Storr who was the leading craftsman of the Royal silversmiths, the firm of Rundell, Bridge and Rundell. The original owner of the silver was Charles Stewart, third Marquess of Londonderry. He had served under Wellington in the Peninsular War as General Sir Charles Stewart, and in 1814 became British Minister in Berlin, but he soon became Lord Stewart and was appointed Ambassador to the Emperor of Austria. Lord Stewart's half-brother, Lord Castlereagh, was Foreign Secretary to King George IV, and at the famous Congresses of Vienna the two diplomats carried out the successful foreign policy that united the kingdoms of Europe against Napoleon. Castlereagh became Marquess of Londonderry in 1821, but only a year later he died, the title passing to his half-brother. The Worcester porcelain of blue, scarlet and gold in an oriental design belongs to a dinner service given by King George III to his physician, Dr. Willis. Upon the walls of the Banqueting Room are great mural paintings of Chinese figures, the chandeliers are in the shape of waterlilies, and the domed ceiling is painted like an immense palm tree, with a silver dragon among the leaves holding in his claws the gigantic central chandelier. From this dazzling cascade of brilliance rise four gilt dragons holding lotus-shaped lamps.

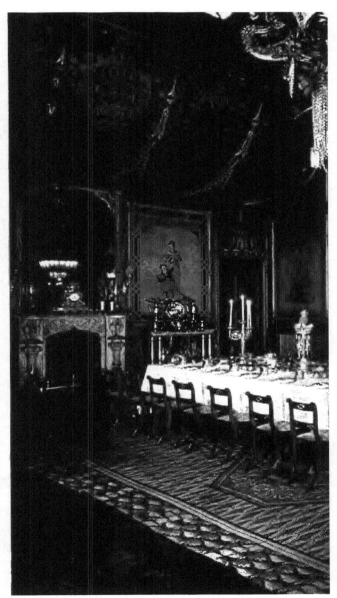

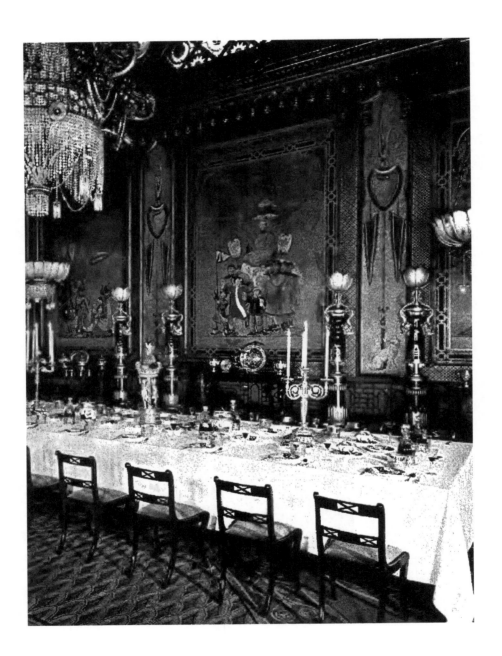

ROYAL APARTMENTS

The King's Private Apartments, consisting of Ante-room, Library and Bedroom, have been restored in recent years by Roy Bradley, a staff artist, with their wall-decoration in white on green, in exact reproduction of the original, and ceilings painted as a clouded summer sky by Derek Rogers. Above is the King's Library, below the King's Bedroom.

* * *

The Royal Pavilion has never ceased to enjoy the interest of the Royal Family. Queen Mary, herself a great connoisseur of antiques, took an especial interest and made some magnificent gifts. The Queen The Queen Mother, The Princess Royal and the Duchess of Kent, have made visits. Her Majesty (then The Princess Elizabeth) is seen (*right*) with the Mayor at the North Gate in 1951.

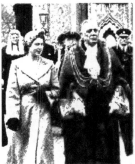

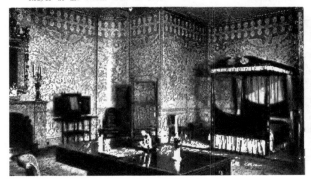

IDYLLIC POVERTY

following year he came again, and this time took a small farm-house to serve as his summer residence.

Soon the Prince of Wales fell in love with the beautiful and twice widowed Mrs. Fitzherbert. After a stormy courtship they were married —secretly, for of course the heir to the Throne could not marry a Roman Catholic, as Mrs. Fitzherbert was. A few weeks afterwards, in 1785, the Prince brought his bride down to Brighthelmston full of resolutions to live a life of idyllic poverty, for he was now overwhelmed by debts, and had been forced to close Carlton House and to sell his racehorses.

It was not long before the Prince's house was found too small and the Prince's architect, Henry Holland, was commissioned to enlarge it. He rebuilt the place in 1787 as an elegant classical villa, with a central domed rotunda and Ionic columns, and flanking wings.

If the circle of friends who joined the Prince's company at the Marine Pavilion included such wild and roisterous spirits as the notorious Barrymore family, there were as well some of the most brilliant wits and intellects of the time. The Prince had thrown in his lot with the King's political opponents, the Whigs. Charles James Fox, the leader of the Whigs, was the Prince's great friend, and Richard Brinsley Sheridan, the famous dramatist, and the party's orator, was an intimate member of the circle. So, too, a few years later was Beau Brummell, the celebrated dandy.

For many years the Prince spent several months every summer at Brighton, and a few weeks at Christmas, and he and his wife and friends passed their time going to the races, bathing in the sea, playing cricket on the Steine, or attending sham naval battles, and reviews of soldiers from the Brighton Camp.

The whole of the populace would turn out on the Downs on these military occasions, in carriages, curricles, phaetons, flys and even farm-carts and fish-carts, and cheerfully create enormous confusion among the opposing lines of troops.

The Prince's economical resolutions had soon been forgotten, and by 1794 his debts amounted to over £640,000. The King would not ask Parliament to settle these debts unless the Prince agreed to contract a marriage acceptable to the State. The Prince's father was apparently

Continued on page 16

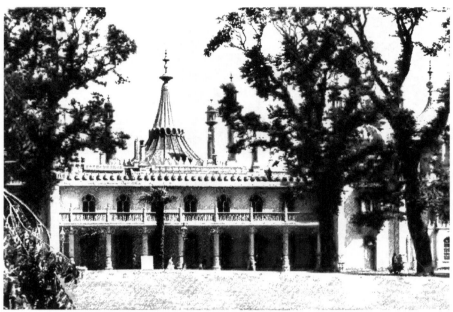

THE WESTERN WING · THE DOME · THE NORTH GATE

The last part of the Pavilion to be completed for George IV, in 1822, was the Western Wing (*above*) with its beautiful colonnade and balcony. On the ground floor the King's Private Apartments were formed, and on the upper floor was a corresponding suite of private apartments, later used by Queen Adelaide. The Royal Stables (*below, left*), now a very fine concert hall known as the Dome, was the first of the buildings to be designed (1803–1808) in the Indian style, inspired by the beauty of the mosques and palaces of India. The North Gate (*below, right*) was built in 1832 also to an Indian design of John Nash's, and commemorates the reign of William IV, 1830–1837.

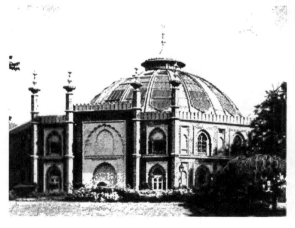

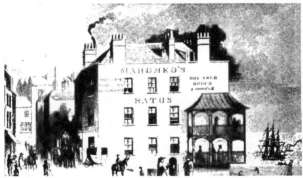

BATHS AND BATHING

The Prince of Wales is supposed to have visited Brighton in the first place to partake of the sea-bathing treatment for his health. In the quaint drawing above he is shown entering a bathing machine. Martha Gunn was "Queen of the Dippers." The original of her portrait by John Russell, R.A. (*right*), hangs today at Buckingham Palace. The child has been given the features of the Prince of Wales, but he did not visit Brighton until he was twenty-one years old. Below is seen one of the establishments where indoor sea-water treatment was given, that of Sake Deen Mahomed, self-styled "Shampooing Surgeon to His Majesty." The "shampooing" was a form of massage carried out through two sleeves in a long flannel tent in which the patient was enveloped to ensure his privacy.

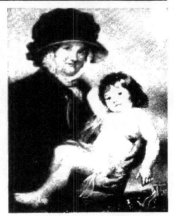

THE CHINESE STYLE

the only person in the land who did not know, or pretended not to know, that his son was married to Mrs. Fitzherbert. Under the pressure of his debts, and in fear of losing his succession to the Throne, the Prince parted from Mrs. Fitzherbert and married Princess Caroline of Brunswick. Shortly after the wedding, in 1795, the pair came down to Brighton.

The Prince soon separated from his bride, but Princess Caroline stayed on at the Pavilion for several months afterwards, sometimes making excursions into the country where she passed the day sitting under a clump of trees gazing sadly at the Downs and the sea. In the following year a child, the Princess Charlotte, was born to her.

After a few more years the Prince became reconciled with Mrs. Fitzherbert, but only when she had obtained the assurances of the Pope that her marriage to the Prince was valid in the eyes of heaven. So opened Mrs. Fitzherbert's second reign at Brighton.

To celebrate this new era of gay life the interior of the Pavilion was entirely re-decorated in Chinese style, with hand-painted Chinese papers of blue, pink and yellow upon the walls, furniture of bamboo and lacquer, and porcelain vases everywhere. This was of course no new fashion ; such decoration, and "Chinese Chippendale" furniture, had been popular in the past, and the Prince himself had a Chinese room at Carlton House ten years before. But the Prince was also toying with the idea of completely re-building the Pavilion as an Indian palace.

Humphrey Repton, the landscape architect, prepared some designs in this new manner, but the Prince became afflicted by another crisis over his debts, and the scheme was abandoned for a time.

One evening in November, 1805, the Prince was at the Pavilion when a messenger arrived with news of the Battle of Trafalgar and the death of Nelson. This great victory was first announced at the Pavilion, for Brighton was then one of the principal Channel ports, and continental news often came to the offices of the *Brighton Herald* before being sent on to London.

The Prince's daughter, Charlotte, was nearly twelve years old when she first came to Brighton in 1807. On her father's birthday she drove over

Page 16

Continued on page 18

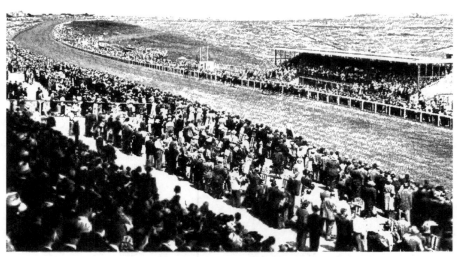

BRIGHTON RACES

Brighton Races, still famous today, began in 1783, the year of the Prince Regent's first visit to Brighton. In 1805 the Prince presented a silver-gilt trophy, "The Brighton Cup," but the race was won by his own horse, Orville, so the Prince gave the cup to his friend Christopher Wilson, "Father of the English Turf," from whom he had bought the horse. The cup is now preserved in the Royal Pavilion. The course stretches along the crest of White Hawk Down, with a superb panorama (*above*) of downs and sea beyond. The lively engraving (*below*) is of a meeting held in 1852.

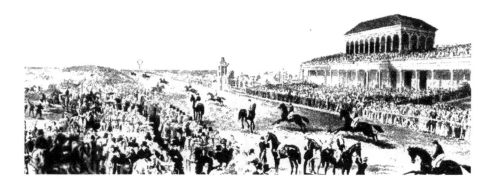

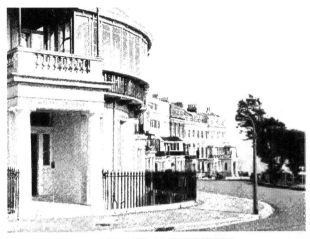

ART AND ARCHITECTURE

The glorious squares, crescents and terraces of the late eighteenth and early nineteenth centuries endow Brighton with much of its beauty, dignity and charm. Sussex Square, in Kemp Town (*above*), designed by the architect C. A. Busby in 1824, opens out seawards into Lewes Crescent, and forms with it one of the finest architectural groupings in the country. Brighton's Art Gallery, close to the Royal Pavilion, contains large collections by the great European Old Masters as well as modern painters; also pottery, musical instruments, furniture, Sussex archaeology, coins and natural history. The lofty main picture gallery (*below*) was originally intended as an indoor tennis court for King George IV.

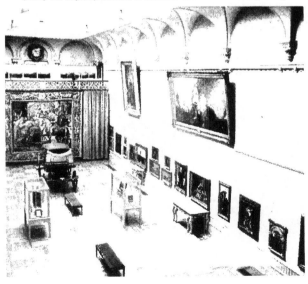

PRINCESS CHARLOTTE

from Worthing to see the sham naval battle and grand review on the Downs which were now indispensable and riotous features of the celebrations. The Princess was shown over the Pavilion by her father, met her uncles, the Royal Dukes, and danced on the lawn to the strains of a band. At the birthday celebrations the next year the poet, Lord Byron, was present. Then only twenty, he was staying at a house on the front with a girl who dressed in boy's clothes. Later Byron wrote to Sir Walter Scott that the Prince's language had given him "a very high idea of his abilities . . . certainly superior to any living gentleman."

One of those who welcomed the Princess Charlotte was Minnie Seymour, Mrs. Fitzherbert's adopted daughter, then nine years old. She was probably the most privileged of all the visitors to the Pavilion, and was so greatly adored by the Prince that they were "Prinny" and "Minnie" to each other.

In 1811, the aged King's mental powers were failing, and his son became Prince Regent. To have acknowledged his marriage with Mrs. Fitzherbert would have nullified his claim to the Throne, and so the final break between them came at last. Four years later, the Regent began the alterations which were to transform his little holiday Pavilion into a Royal palace.

The Great Kitchen, Long Gallery and Entrance Hall were finished when the Princess Charlotte came to stay for the Christmas of 1816, together with Prince Leopold of Saxe-Coburg, to whom she had just become engaged. It was then that the Princess and her father became reconciled after their long quarrel over her choice of a husband.

Alas! after little more than a year the Princess died in childbirth, and her baby with her. The Prince Regent was heartbroken and retired to Brighton, and it was a long time before he could arouse any interest in the alterations that were going on.

John Nash, who was now the Prince's architect, had been carrying out a great programme of building in London, creating Regent's Park, Regent's Street, Carlton House Terrace, and re-building Buckingham Palace. At Brighton, Nash added two great new State Apartments, the Banqueting Room and Music Room, and the whole of the exterior was transformed into a fairy tale palace.

The famous Chinese decoration of

Continued on page 20

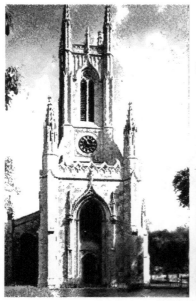

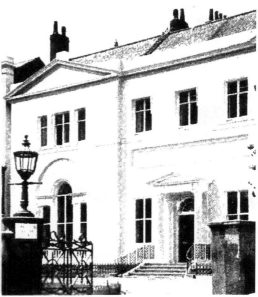

GEORGIAN ELEGANCE

Soaring out of the Valley Gardens (*above, left*) is the dazzling white Portland stone tower of the Parish Church of St. Peter. A fine example of the early Gothic revival, it was designed by Sir Charles Barry, architect of the Houses of Parliament, in 1824. The architect Robert Adam built Marlborough House (*above, right*), now the Education Offices, about 1786, in his characteristic style of refined elegance. Royal Crescent, on the East Cliff (*below*) was built between 1798 and 1807, and is faced with black glazed tiles that contrast brilliantly with the white-painted windows. The Western Pavilion (*right*) was the home, built 1827, of one of the great Brighton architects, Amon Henry Wilds.

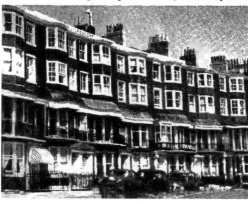

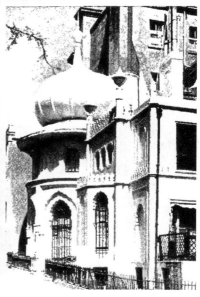

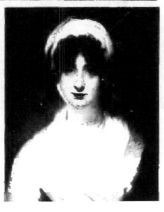

THE THEATRE ROYAL

The Theatre Royal in New Road was named after a visit of the Prince of Wales, and built in 1806. The bow-windows and elegant colonnade (*above*) date from about 1826. The new theatre opened under the Prince's patronage with Mr. and Mrs. Roger Kemble in "Hamlet." Grimaldi, Edmund Kean, Madame Vestris and Sarah Siddons (*right*) are among the immortals of the stage who have played in Brighton. Today's stars are creating new traditions for the Theatre Royal in the first productions for which it is famous. As many as fourteen plays running in London at one time have been first staged here.

THE PAVILION CLOSED

the interior remained, but with a change in spirit. In place of the early barbaric exuberance and gay colouring, the rooms took on a stateliness and more formal grandeur, which seemed to express something of the Prince's sense of the new responsibilities now falling upon him. As the rooms approached completion in 1820, the old King died. The Prince Regent succeeded him as George IV.

His Coronation was celebrated by the roasting of a whole ox on the Level. The sports and dancing held there in the afternoon were a complete fiasco because through "potent libations of ale . . . order became lost in unspeakable rapture." Several people were injured "yet the loyal character of the assembly was never for an instant lost!" Some smugglers took advantage of these diversions to get away from the beach with about thirty kegs of Hollands gin on which duty had not been paid.

In January 1827 the King came to the Pavilion for the last time. Soon afterwards he retired to the seclusion of Windsor, and died there in 1830.

So passed one of the most maligned of monarchs, yet who left behind him achievements equalled by few others. The friend of artists and writers, and a connoisseur, he was the founder of the great Royal art collections: the firm supporter of Wellington, he ruled England during the momentous years of the Napoleonic wars.

His brother, the Duke of Clarence, succeeded him as William IV, and lived with Queen Adelaide at the Pavilion for long periods. One of the King's first acts was to call upon Mrs. Fitzherbert, and she enjoyed his friendship until her death in 1837, in which year the King also died. Her monument, showing her wearing three wedding rings, is in the church of St. John the Baptist, Kemp Town.

Although the young Queen Victoria came to Brighton with her husband, the Prince Consort, and their children their visits were few and fleeting. Brighton had grown up so closely around the Pavilion that there was little privacy, and the Royal couple were mobbed whenever they walked through the streets. In 1845 the Pavilion was closed, and it was expected that it would be demolished. The furniture and decorations were removed to Buckingham Palace, and the place was left an empty shell.

Continued on page 22

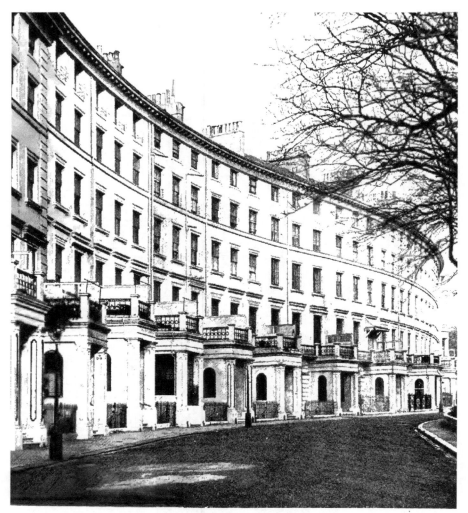

ADELAIDE CRESCENT

Beyond Brunswick Town to the west, Adelaide Crescent is the last of the great architectural groups of the sea-front built in the spirit of the Regency. It commemorates Queen Adelaide and was designed in 1830 by the architect Decimus Burton, who had assisted Nash with the building of the Regent's Park terraces. He also designed the Athenaeum Club, London, and town-planning schemes at Tunbridge Wells and Hastings. It was not until 1850 that the crescent was completed, and its architecture is of the strongly Italian character which followed the Regency style.

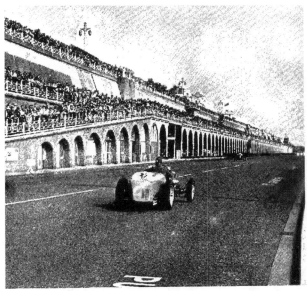

SPEED TRIALS · OLD CROCKS' RACE

The Madeira Drive, east of the Palace Pier, is the finishing stretch for annual sporting events such as the London to Brighton Walk, the Relay Races, and the Veteran Car Run. The latter is held in November on the anniversary of the first organized drive in 1896 of motorists to celebrate emancipation from the man who till then had to walk in front with a red flag. The famous veteran car "Genevieve" is seen (below) arriving at the finishing post. In September, International Speed Trials (above) are held along the measured kilometre of the Drive.

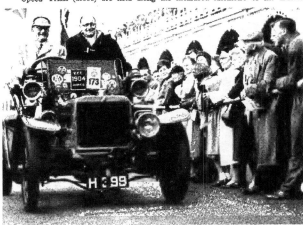

BOUGHT FOR £50,000

However, the townspeople had developed an intense affection for the outlandish building in their midst, and they succeeded in purchasing it from the Crown for £50,000. It had cost with furnishings and decoration over half-a-million.

The Pavilion was henceforth used as the assembly rooms of the town, and Queen Victoria later returned many decorations, especially chandeliers and wall paintings.

The most important event in the history of the building during the last hundred years has been the return from Buckingham Palace in 1956 and onwards of over a hundred articles of the original furniture designed for the Pavilion, such as bamboo and lacquer cabinets, bamboo chairs and many other decorative objects. These have enabled the Pavilion to be restored even more closely to its appearance at the time of King George IV, and the building is today appreciated more than ever before for its importance and interest as a past Royal residence, as an historic building, and a monument of the art and life of the Regency age.

During the forty years of patronage of George IV as Prince of Wales, Prince Regent and King, the town developed continuously, and there arose those grand squares and terraces of monumental houses, and the more intimate smaller residences, that give Brighton its distinctive charm and appeal as a Regency town. The greater part of this astonishing architectural development took place between 1822 and 1828. During 1826 alone five hundred houses were under construction.

At Queen Victoria's Coronation whole oxen were again roasted on the Level, and it seems that each of the charity school children received over half-a-pound of roast beef and a glass of wine.

During the '60s and the '70s the nobility and aristocracy flocked to Brighton every year, especially in the autumn. One writer said "You can scarcely rest your eye on anything commoner than a Knight, and there are Commanders of the Bath enough to lift up Brill's Baths bodily and cast it into the sea!"

Each afternoon during the season there was a fashionable parade of handsome carriages along the seafront, and in the evenings there were balls and assemblies at the Old Ship. Most of the principal literary and theatrical figures of the day came to Brighton. Dickens gave a reading at

Continued on page 24

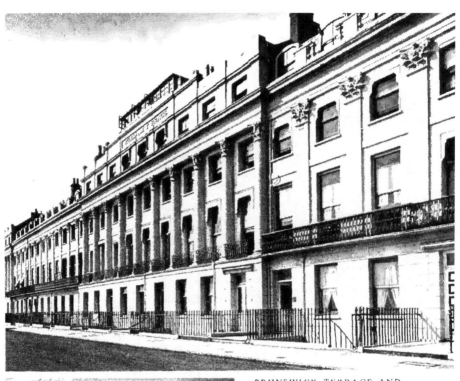

BRUNSWICK TERRACE AND BRUNSWICK SQUARE

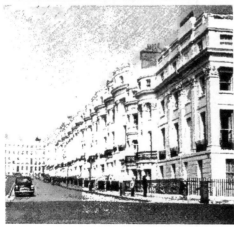

Brunswick Town, as it used to be called, is the second of the two great town-planning groups of the Regency period which lie at either end of the sea-front of Brighton and Hove, and corresponds to Kemp Town in the east. The magnificent scheme was designed by the architect, C. A. Busby, in 1825, in emulation of the great developments in Regent's Park, London. It consists of Brunswick Square (*left*), opening on to the sea-front, where it is flanked on either side by the two immense ranges of Brunswick Terrace, one range of which is seen above. The terraces are each planned as a single palatial unit, fronted with columns of the Corinthian order. In the square the house-fronts with their boldly curving bow-windows, fluted Ionic columns and deep cornices are modelled into strong relief by the sunlight, and the cast-iron balcony railings at the first-floor windows are made in a delightful variety of graceful designs.

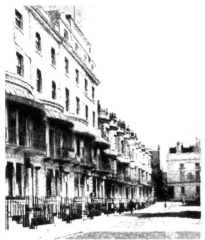

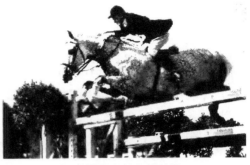

BRIGHTON HORSE SHOW

Every summer in July, when the Brighton Horse Show and Jumping Championships are held in Preston Park, many of the great stars of the equestrian world are to be seen. Clearing the triple fence in fine style on a handsome grey (*above*), is Miss Pat Smythe.

REGENCY SQUARE

Regency Square, (*left*), with its pattern of bow-fronts and canopied balconies sums up the charm of Brighton's smaller Regency houses.

ALL THINGS TO ALL MEN

the Pavilion, Paganini played at the Old Ship, and Jenny Lind was paid £500 for singing at the Town Hall.

All the coaches except "The Age" stopped running with the opening of the railway, but in 1866 there was a successful revival of coaching, which has never entirely ceased since. Horace Smith summed up the charm of Victorian Brighton in a poem which ended:

"*Long shalt thou laugh thine
 enemies to scorn,
Proud as Phoenicia, Queen of
 watering places!
Boys yet unbreeched, and maidens
 yet unborn,
On thy bleak downs shall tan their
 blooming faces.*"

Brighton is notable for its magnificent churches of the Victorian period that worthily continued the tradition of church building begun in Regency days—St. Michael's containing windows by Rossetti and William Morris, St. Paul's with a Burne-Jones altar-piece, and towering St. Bartholomew's, the greatest of all, so modern for its date of 1874. St. Martin's is one of the most beautiful of those associated with that fervent Victorian divine, the Rev. A. D. Wagner, who gave five churches to Brighton.

The growing interest in science in the 19th century was reflected in

the building of the Aquarium, and by the holding in 1867 of a great exhibition of science, industry and art in the Dome and the Riding House, which had now become the Corn Exchange. In 1873 the stable buildings fronting upon Church Street were converted into a Public Library, Art Gallery and Museum. Several large and distinguished private collections have made the Library one of the richest in the country, and the Art Gallery and Museum are now celebrated for their important collections of Old Master paintings, English pottery, primitive art, archaeology and natural history. The Dome is now the home of the Southern Philharmonic Orchestra.

In Edwardian days the King himself led the world of fashion in patronising the town, visiting such friends of his as the Sassoons at their houses in Eastern Terrace and Brunswick Terrace. The motor-car restored the glories of the Brighton Road, and during the First World War the Pavilion achieved a strange fulfilment when it became a hospital for wounded Indian soldiers.

In the last conflict visitors were banned and the sea-front was fortified against Hitler's threat of invasion. A pleasure arcade became a machine gun post still with its name "Fairyland" in coloured electric bulbs. A public house on the lower

promenade had its windows sandbagged and festooned with barbedwire, its signboard swinging in the wind bearing the ironically appropriate name, "The Fortune of War."

Modern Brighton is all things to all men. In her early days the two factions of the population, the fisherfolk and the landsmen, were strictly divided by the line of the cliffs. Now all sections of society merge together and everyone feels at ease. The racegoer, the music-lover, the theatrical first-nighter, the connoisseur of Regency art and architecture, the sportsman, the delegates of the great professional and political conferences, the lovers, the young honeymoon couple; the tired actor, Cabinet minister or city clerk, all find something to satisfy them and all are united in their pleasure in the air, the sea, the sky, the gaiety, the elegance—the brilliancy of Brighton.

ACKNOWLEDGMENTS

The publishers are grateful to the Brighton Corporation for permission to reproduce the colour photograph of the Banqueting Room of the Royal Pavilion on pages 12-13, a number of black and white photographs, old prints and drawings from the Brighton Art Gallery, and the Borough coat of arms. The colour photograph of the Royal Pavilion on the front cover and on page 9 is by the British Travel and Holidays Association.

Page 24

Lightning Source UK Ltd.
Milton Keynes UK
UKHW020607240223
417573UK00005B/231